HERMANN STENNER

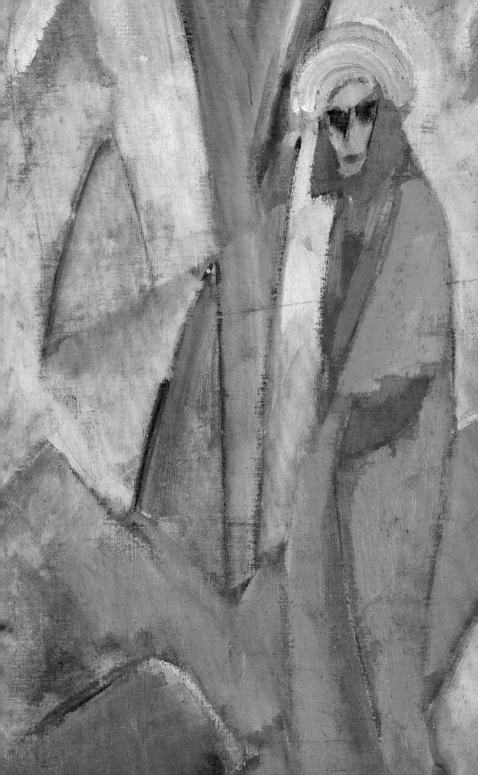

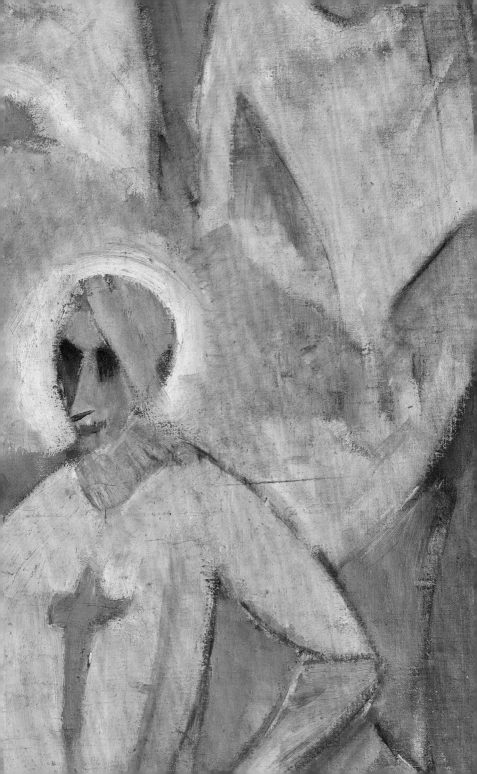

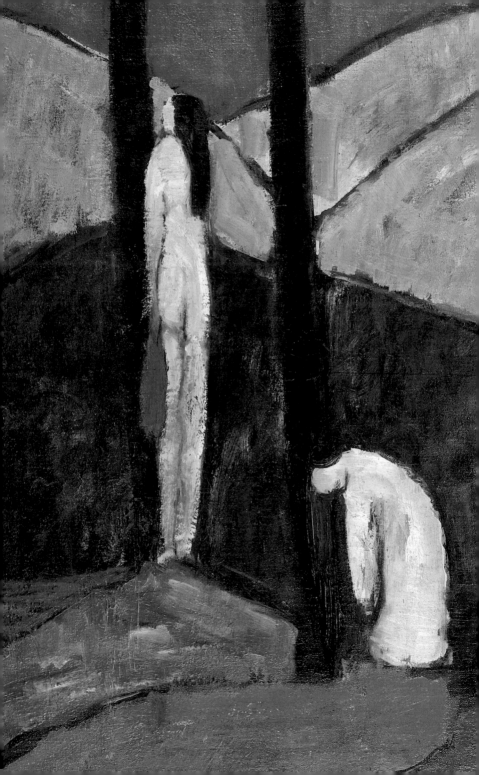

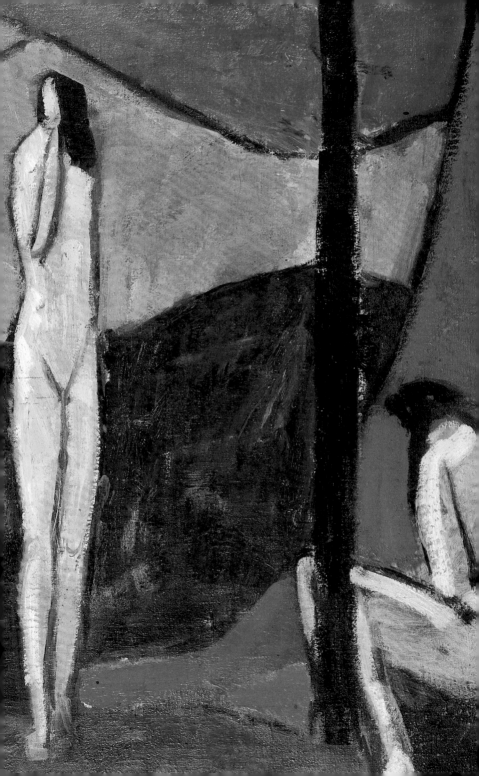

HERMANN STENNER

A Pioneer of
German Expressionism

Christoph Wagner

HIRMER

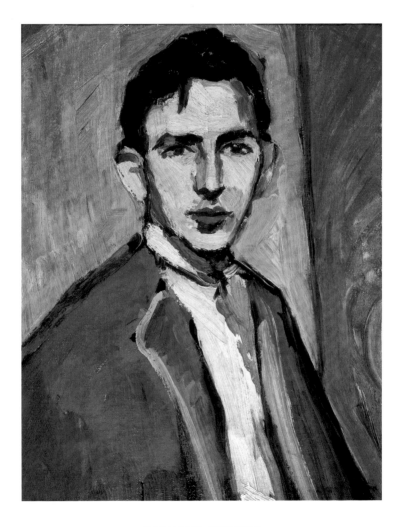

HERMANN STENNER
Self-Portrait with Red Jacket, 1911, oil on cardboard,
50.5 × 40 cm, private collection

CONTENTS

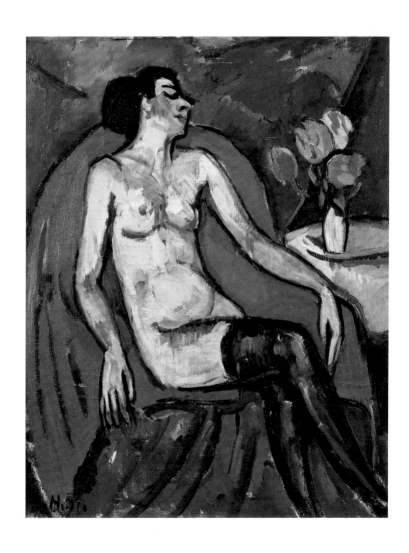

1 *Seated Nude with Bouquet of Roses on the Table*, 1911,
oil on canvas, 91 × 73 cm, Kunstmuseum Stuttgart

HERMANN STENNER

—

A PIONEER OF GERMAN EXPRESSIONISM

In the spring of 1936 the founding director of New York's Museum of Modern Art, Alfred H. Barr Jr., presented in his pathbreaking exhibition *Cubism and Abstract Art* the guidelines for an international reappraisal of early 20th-century European avant-garde movements. By that time the German Expressionist Hermann Stenner, born in Bielefeld on March 12, 1891, had been dead for nearly a quarter of a century and virtually forgotten. On December 5, 1914, destiny had felled the 23-year-old in the trenches of the First World War's Eastern Front, just as it would later the older Franz Marc (1880–1916) on its Western Front. "At twenty-three Hermann Stenner was the youngest expressionist painter to die in the war."[1] Barr at least mentioned Franz Marc as a key figure among the "pre-War Munich Expressionists" and member of the "Blue Rider group of Munich Expressionists,"[2] including one of his gouaches among the show's 400 works, whereas Hermann Stenner and the Stuttgart Expressionists around Adolf Hölzel were not mentioned.[3] Stenner and the "Hölzel circle" do not appear in the now-famous diagram of the origins and influences of modern art reproduced on the catalogue's dust jacket, nor do Dresden's Die Brücke Expressionists Ernst Ludwig Kirchner, Erich Heckel, Karl Schmidt-Rottluff, Max Pechstein, and Otto Mueller. Stenner had died too

early for his art to be included in most of the overviews of Expressionism published a few years after his death.[4] It was only the art historian Hans Hildebrandt (1878–1957), intimately familiar with the "Hölzel circle", who mentioned Hermann Stenner—twice in fact—in his 1914 *Art of the 19th and 20th Centuries. A Handbook of Art History*.[5]

In contrast, Barr named only Willi Baumeister and Oskar Schlemmer, presumably at the suggestion of Lyonel Feininger, under the cryptic designation Stuttgart "Compressionists," with their attempt "to clarify the Cubist tradition and turn it into a more architectonic style."[6]

That after Hermann Stenner's death a majority of his roughly 1,800 works—like his painting *Seated Nude with Bouquet of Roses on the Table* (fig. 1)—were saved and survived two world wars, was initially thanks to the valiant commitment of his Stuttgart artist colleagues and friends, among them Adolf Hölzel, the later Bauhaus master Johannes Itten, and Hans Hildebrandt. Afterwards it was thanks to his family, who stored the works for decades in the attic of his parents' house on August-Schroeder-Strasse in Bielefeld. Stenner's father Hugo died in 1918, two brothers also fell in the war, his sister Lissi, whom Stenner portrayed (fig. 2), died of the Spanish flu in 1918, and the family business was failing, yet the family never wavered in its dedication to Hermann's memory.[7] As early as 1932 a portion of the artistic estate ended up in North America when his younger brother Walter emigrated to Canada, and remained there under seal in a private collection for decades until 2019. It included such paintings as *Viaduct near Montjoie* (fig. 20), *Fair on the Kesselbrink* (fig. 3), and *Crusader and Christ* (fig. 26). Likewise, several works in the possession of Stenner's Stuttgart friends survived the Second World War unscathed: in the Hildebrandt Collection, the Hugo Borst Collection, and in the possession of Clara Bischoff.

As part of the "cleansing" of German art collections of "degenerate art" in National Socialist Germany works by Stenner were confiscated—from the Staatsgalerie Stuttgart and the Städtisches Kunsthaus Bielefeld for example—and presumably destroyed in 1937, and others, such as those in the noted Eberfeld private collection of the art patron August Freiherr von der Heydt (1851–1929), were destroyed during the Second World War.[8] The pictures in the Bielefeld attic, however, survived until they were rediscovered by the German art historian Gustav Vriesen (1912–1960). In 1956, twenty years after Barr's epochal exhibition and catalogue on German

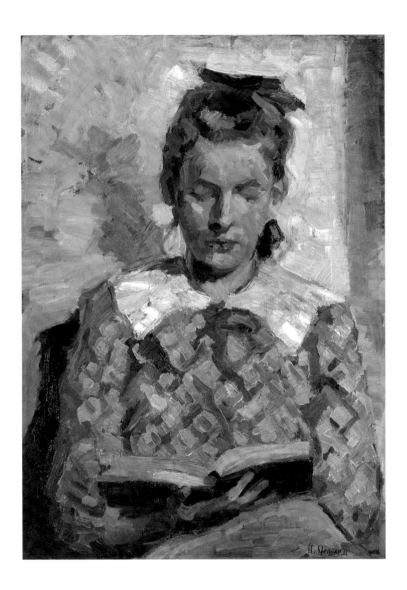

2 *Lissi*, 1910/11, oil on canvas, 60.5 × 43.5 cm, Sammlung Bunte

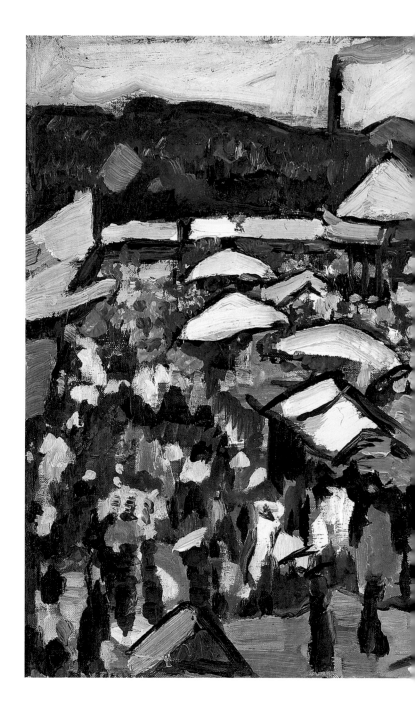

3 *Fair on the Kesselbrink*,
1912, oil on canvas,
49 × 59.5 cm, Sammlung
Bunte

avant-garde movements, Vriesen devoted an important exhibition to the art of Hermann Stenner at the Städtische Kunsthalle Bielefeld, of which he was director, thereby reawakening appreciation for the artist. With his exhibition catalogue Vriesen filled a gap in the mapping of Expressionist Modernism: "Hermann Stenner is today an unknown quantity. He needs to be restored to the art world. The painterly oeuvre the 23-year-old left behind in his Stuttgart studio in 1914 is one of the constructive forces of modern art in Germany. Without him the art-historical picture of that early period remains incomplete."[9] Willi Baumeister, who later worked as an artist and professor at the Stuttgart Art Academy and was also intensely committed to a new beginning and link with international art developments, never forgot his fallen friend, and was an emphatic champion of Stenner's art. On June 15, 1950, for example, he wrote to Stenner's family: "Stenner was a lively, jovial man and artist. His achievements were outstanding. ... I have a high regard for Hermann's paintings. ... His art was a great flourishing without hesitation and interruption. ... Hermann Stenner would have become one of Germany's finest painters if the senseless, criminal war had not sacrificed him."[10]

In Barr's characterization of the lines of development in modern art he asserted that "the more adventurous and original artists had grown bored with painting facts. By a common and powerful impulse they were driven to abandon the imitation of natural appearance."[11] It is a description that can most certainly be applied to Hermann Stenner's work, even though in his brief lifetime he, unlike Franz Marc, Johannes Itten, Willi Baumeister, or Oskar Schlemmer, never took the step into geometrical abstraction without any tie to objectivity.

All in all, Hermann Stenner was not even granted a full five years in which to leave behind some 300 paintings and more than 1,500 works on paper, an astonishing oeuvre for such a brief career. How does one do justice to such an artist whose phenomenal imaginative gift left its mark from the very beginning, but whose potential for future development remains forever hypothetical? How does one write a history of an abruptly truncated artistic career compressed into a mere five years? As freely and compulsively as in his painting (fig. 1), Stenner enlisted in the war machinery of the First World War in a moment of patriotic fervor, one that would devour him—like so many others of his generation—in its first skirmishes. Hermann Stenner's brief life ended on the Eastern Front on the morning of December 5, 1914, and provides ample reason to reflect on the aphorism customarily attributed to Hippocrates, "Ars longa, vita brevis," as well as on the senselessness of the patriotic "hero's death." More than one chapter in art history was deleted by this war, and one forgets all too readily the existential meaning of the quoted dictum, namely that a single human life is short and inconsequential as compared to the breadth of possibilities for art. This might sound somewhat forced after a long, fulfilled artist's life in view of man's essential mortality, but in regards to the young generation of European artists lost in the First World War the notion takes on a bitter dimension all its own: roughly 600 artists from all over Europe lost their lives in the First World War.[12] Interestingly, this bleak finding was reflected even before the end of the First World War, also with regard to the fate of Hermann Stenner, by Hans Hildebrandt in his book *War and Art*, published in 1916, which grew out of a talk at the beginning of the war, in the winter of 1914/15, at Stuttgart's Technische Hochschule. There he laments: "The great slaughter has shockingly done away with the best of our youth. We have lost Hermann Stenner, not yet 23 years old, who nevertheless had already painted many a picture that was far more than a brilliant example of his talent, many a picture to which a powerful rhythm and idiosyncratic color harmony lent lasting value. And we mourn in this richly gifted Bielefelder, who managed to integrate Hölzel's stimuli in such a personal way, a charming person filled with easygoing youthful exuberance."[13]

It is highly tempting to follow Hermann Stenner's path through the "isms" of his day, for of course even a young artist as exceptional as Stenner was a child of his time. Needless to say, his teachers—Heinrich Knirr in Munich, the plein-air painter Hans von Hayek at the Dachau artists' colony, the Late Impressionist landscape painter Christian Landenberger at Stuttgart's Academy, and especially Adolf Hölzel, also at the Stuttgart Academy after October 1911—left obvious traces in his artistic work. And his impressions from the epochal *Sonderbund Exhibition* in Cologne, with more than 200 leading examples of contemporary art by Paul Cézanne, Paul Gauguin, Vincent van Gogh, Edvard Munch, Pablo Picasso, and Paul Signac, which Stenner visited in the summer of 1912, did not fail to leave their marks on the work of the young painter (fig. 4). Additionally, there were his exchanges with prominent artist colleagues in what became known, beginning in 1916, as the "Hölzel circle" of Stuttgart pupils. There Stenner worked alongside Willi Baumeister, Ida Kerkovius, Johannes Itten, and Oskar Schlemmer. For a brief moment figures important for later avant-garde movements were gathered around Adolf Hölzel, a virtual focusing mirror of art history, and inspired each other. Stenner had become his pupil in October 1911, and by the spring of 1912 was already a Hölzel master-class pupil. In this circle he enjoyed great respect and was treated like a young star, even granted the use of a master's studio "with telephone," as Stenner boasted to his family.[14] All this soon made him forget that he had initially found the sedate minor capital of Stuttgart a less inspiring place for a young artist than the vibrant art metropolis of Munich. He increasingly distinguished himself in public exhibitions and commissions: his pictures were shown in Munich's *Jury-Free Exhibition*, the *Künstlerbund Exhibition* at Stuttgart's Württembergischer Kunstverein, and in the Künstlerbund's and the Academy's *Christmas Exhibitions*. In 1913 he was able to participate with several paintings in exhibitions in Berlin, at the Neuer Kunstsalon in Munich, at the Kunstsalon Fischer in Bielefeld, and in other shows in

previous double page:
4 *The Red Field*, 1913, oil on canvas, 43.7 × 59.2 cm, Kunstsammlung Rudolf-August Oetker, Bielefeld

5 *Cubist Street Scene*, 1913, oil on canvas, 46.3 × 37.4 cm, inv. no. 1305 I.M,
LWL-Museum für Kunst und Kultur (Westfälisches Landesmuseum), Münster

Vienna and Stuttgart. An invitation to participate in the important *Expressionist Exhibition* at the Galerie Ernst Arnold in Dresden and the ambitious commission to produce—together with Willi Baumeister and Oskar Schlemmer—mural paintings for the entrance hall of the main building at the Cologne *Werkbund Exhibition* in 1914 would follow (fig. 32).[15] These connections and networks assured Stenner's brief career a prominent place in art history from the beginning. Prices for his works rose quickly to remarkable heights.

In his art Hermann Stenner thus participated in artistic developments arising in the rivalry between competing "isms," yet pursued his own expressive imagery. His painting exhibits different accents, now a more Expressionism-oriented coloring (fig. 1), now a dissection of forms more Cubist in style (figs. 5, 6) but is still tied to an artistic engagement with the representation of figures and objects. In this he followed his teacher Adolf Hölzel's fundamental convictions. Only in a few late works, as in the 1913 painting *The March* (fig. 7), is it clear that Stenner also ventured into the field of largely rhythmic, abstract pictorial compositions. Other works moreover document how early he took notice of *Der Blaue Reiter*, an almanac of epochal importance for the development of Modernism that was published in May 1912, marking the opening of the extensive second Blue Rider exhibition in the Kunsthandlung Hans Goltz.[16] Just as for Adolf Hölzel, for Stenner the overriding goal of his artistic experiments was a creative exploration of the abstract dimensions in the representation of objects themselves. He failed to make the paradigm shift to an effective, aesthetically conceived "pure" abstraction, as did Johannes Itten, Oskar Schlemmer, and Willi Baumeister starting in 1915, at least for some time. This was not so much a stylistic or conceptual decision as a fundamental desire to make art appealing to look at; more than that of many other artists in this circle, Stenner's painting was constantly defined by a distinctly physical concept of his painterly materials.

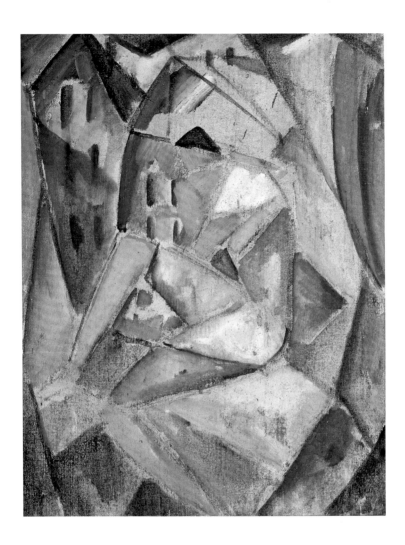

6 *Cubist Figure with Houses*, 1913/14, oil on canvas,
62.5 × 51 cm, Sammlung Bunte

7 *The March*, 1913, oil on canvas, 76 × 64 cm,
Kunstmuseum Stuttgart

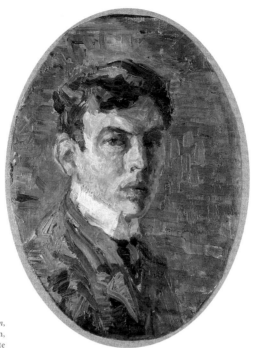

8 *Self-Portrait in Shades of Green*,
1909, oil on canvas, 49.7 × 36 cm,
Sammlung Bunte

ARTISTIC BEGINNINGS AND EARLY STAGES

Even in his early painterly attempts like the *Self-Portrait in Shades of Green*,
from 1909 (fig. 8), one sees a direct grasp of the three-dimensional, physi-
cal qualities of his painting materials; at times he models his pigments
almost like a sculptor into a representation of what he sees. From the first
moment on, his handling of the brush was strong and self-assured—
regardless of the stylistic approach he happened to be trying out. Not only
do the visible body parts in Stenner's early paintings take on this almost
palpable plasticity, but often the flat backgrounds as well, even reflections
in water, as in the picture of Dachau's Schleissheim Canal lined with chest-
nut trees (fig. 9). It is characteristic of Stenner's painting that he integrated
such reflections, rendered in French Impressionism with a maximum of
dematerialization and atmospheric lightness, almost tectonically into a
pictorial structure composed of strong blacks, greens, and violets. It was

9 *Canal Lined with Chestnut Trees*, 1909, oil on canvas,
45 × 61 cm, Sammlung Bunte

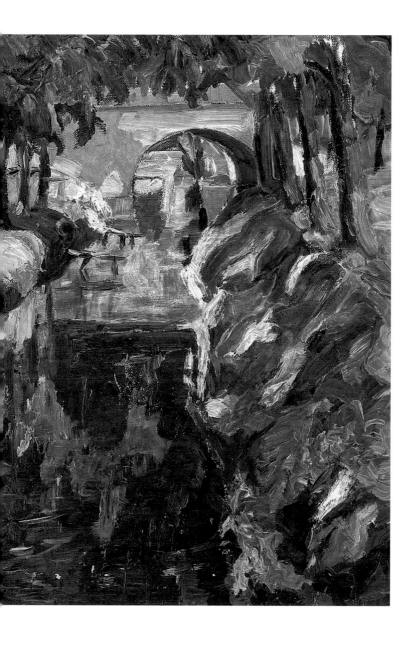

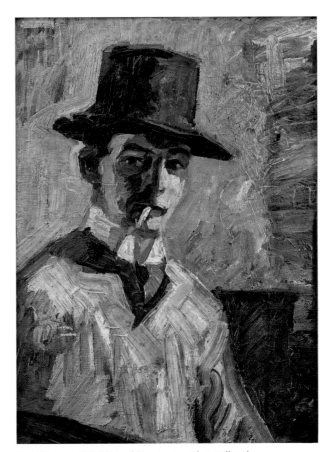

10 *Self-Portrait with Tall Hat and Cigarette*, 1910, oil on cardboard,
49 × 37 cm, Sammlung Bunte

precisely this painting that so delighted the Dachau plein-air painter Hans von Hayek that he recommended the 18-year-old Stenner to the Late Impressionist landscape painter Christian Landenberger at Stuttgart's Academy.[17] Stenner developed his painterly qualities, especially in figural depictions from 1910/11, with an increasingly magisterial lightness, as in *Self-Portrait with Tall Hat and Cigarette* (fig. 10), in which the color-drenched brushstrokes appear to fly by themselves onto the canvas by way of the painter's hand, dissolving in its reflection, and frame the artist's self-confident gaze with a range of painterly values worthy of a Lovis Corinth.

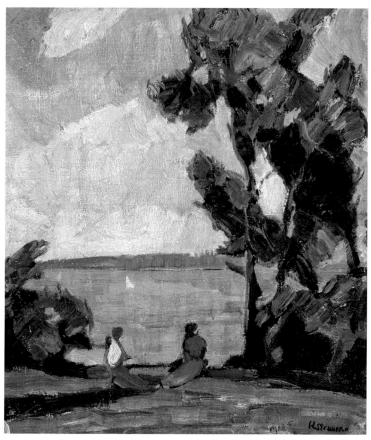

11 *Trees with Two Figures by the Lake*, 1911, oil on canvas,
55 × 48.5 cm, Sammlung Bunte

Stenner's more painterly style is also evident in the portrait of his 12-year-old sister Lissi reading (fig. 2), which in an exhibition by Landenberger's pupils earned him recognition and a prize, as Stenner proudly telegraphed to his parents on March 14, 1911.[18]

In the period between April 1910 and October 1911 Stenner's painting under Christian Landenberg's tutelage takes on a new coloristic lightness and radiance (fig. 1). He also adopts an unmistakably more disciplined brushstroke, especially in the landscapes and plein-air scenes painted during a summer sojourn in 1911 in Diessen am Ammersee. In the painting

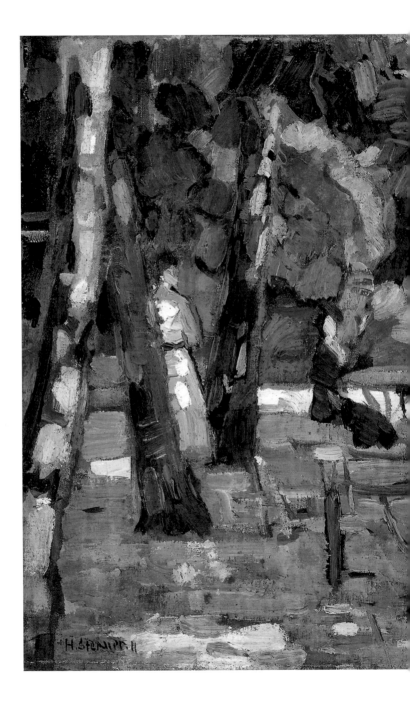

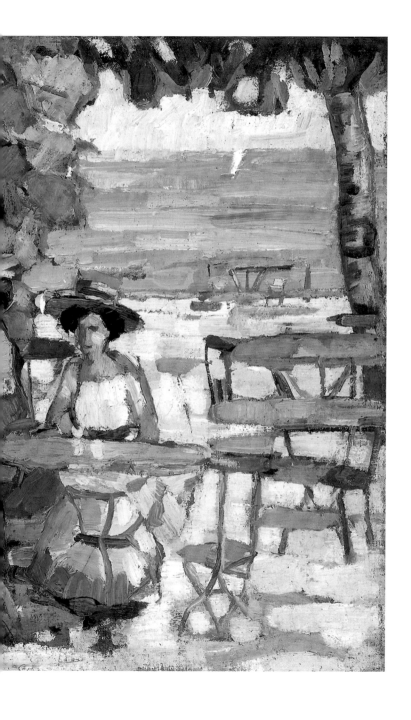

Trees with Two Figures by the Lake (fig. 11) this sovereign assurance in his brushstrokes, in combination with a precise weighting of visual pictorial elements, is as worthy of study as it is in the vivid color values in *Coffee Garden on the Ammersee* (fig. 12). At the same time, one sees here that Stenner was aiming to stabilize the lightness of impressionistic glimpses of life in a new form with his planimetrically arranged color structure. At this point he had already internalized the artistic dictum of Paul Cézanne, venerated in Germany as the "father of Modernism" at least since Julius Meier Graefe's 1910 study on him, that one should not merely model but modulate with color, so as to structure the painting on the pictorial surface as a "harmony parallel to nature."[19] Accordingly, for Stenner color, as opposed to drawing, takes on an essentially new, universal value. He ultimately applies this recognition to his depictions of regional life, as in his *Fair on the Kesselbrink*, from 1912 (fig. 3), which pictures the gay activity of a folk festival between colorful market umbrellas and carousel roofs in front of the Bielefeld city silhouette with the synagogue in the background.

STENNER AND ADOLF HÖLZEL

In October 1911 Stenner switched to the so-called "composition class" taught by Adolf Hölzel, who had joined Landenberger on the faculty of Stuttgart's Academy in 1905 at the age of 52. This was doubtless a calculated decision, and one that would have important consequences. From then on Stenner facetiously referred to himself as a "composition pupil."[20] It is fascinating to note how smoothly and independently Stenner reorients his painting in only a few weeks toward Hölzel's "doctrine of the primacy of pictorial mediums." He also adopts Hölzel's ideas regarding the "harmonics of painting," his color and proportion theories, the doctrine of the golden section, and a rhythmically composed pictorial structure, but without anywhere imitating Hölzel's art. If one compares the painting *Cannstatt Bridge* (fig. 13), produced under these new guidelines, with the painting

previous double page:
12 *Coffee Garden on the Ammersee*, 1911, oil on canvas,
51.5 × 69 cm, Sammlung Bunte

Canal Lined with Chestnut Trees (fig. 9) painted in Dachau only two years before, one clearly sees how decisively Stenner has replaced the previous atmospheric flow of visual impressions with a rhythmic pictorial structure with striking graphic contrasts. In different motifs and genres Stenner experiments with these new forms of representation and composition, whether in the Cézanne-like *Still Life with Apples* (fig. 14), the lifelike *Sketch for a Self-Portrait* (fig. 15), *Rhythmic Landscape* (fig. 16) and *Viaduct near Montjoie* (fig. 20), the latter two painted in the Eifel, or finally in religious subjects, which are also found in quantity in Hölzel's work at this time, among them the strangely unconcerned *Saint Sebastian* (fig. 17).

Stenner profited in multiple ways from his studies with Hölzel, who as an Academy teacher was uncommonly liberal, one who followed his pupils' progress with more encouragement than criticism, and who regularly expounded his theories in evening lectures. Unlike Ida Kerkovius or Johannes Itten, for example, Stenner appears to have been little interested

13 *Cannstatt Bridge*, 1911, oil on canvas, 57.9 × 70.8 cm, Kunstsammlung Rudolf-August Oetker, Bielefeld

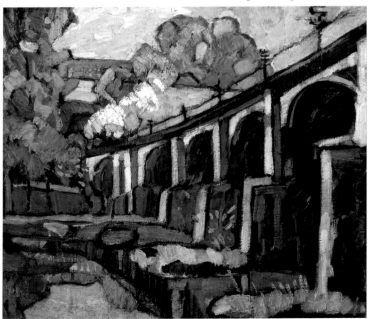

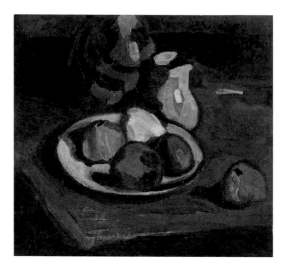

14 *Still Life with Apples*, 1911, oil on canvas, 40.5 × 44 cm, Sammlung Bunte

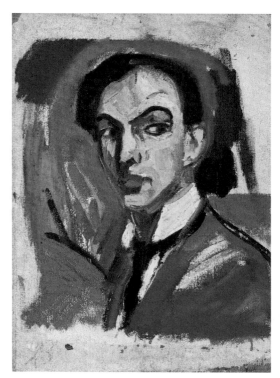

15 *Sketch for a Self-Portrait* (verso: *Rhythmic Landscape, Eifel*, fig. 16), 1912, oil on rough burlap, 65 × 47 cm, Sammlung Bunte

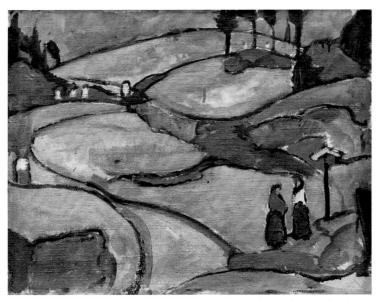

16 *Rhythmic Landscape, Eifel* (verso: *Sketch for a Self-Portrait*, fig. 15), 1912,
oil on rough burlap, 47 × 65 cm, Sammlung Bunte

in theoretical pronouncements except as they applied to his own painterly
practice. His notes on them could not be more concise. In his sketchbook
from 1911/12 we read: "In color, work with the contrasts—and later
balance."[21] Stenner was no *pictor doctus*, he was not given to theoretical
thinking. Reflection on seeing itself entered into his pictures in a new
form. This is what accounts for the intelligence of his painting, the aim of
which he described in only a few lines: "The ideal that I think of as my goal
is being able to express the psychological in nature, whether in a person,
an animal, or a landscape, through color and line. Making my colors a
means of expression. Expressing my feelings about the object."[22] Stenner
likewise commented on the psychological impact of his art in his last letter
of June 19, 1914: "Pure color and the line are means of expression that our
predecessors, the Impressionists, neglected. ... A blue figure before a dark-
red background, for example, stirs a different feeling in us then if the same
figure were yellow. We thus work with psychological effects."[23]

Stenner's first decidedly expressionistic painting, *Seated Nude with
Bouquet of Roses on the Table* (fig. 1), must have had the effect of a thunder-

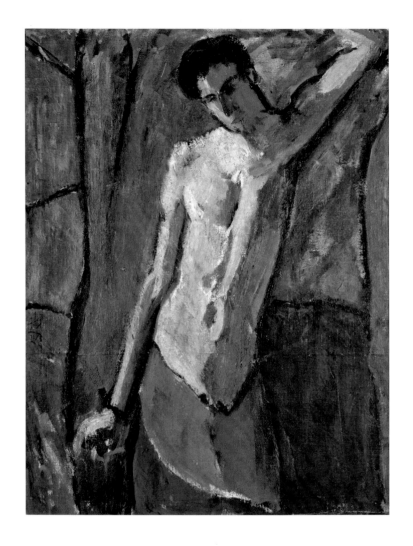

17 *Saint Sebastian*, 1911/12, oil on canvas, 95.5 × 74 cm, Sammlung Bunte

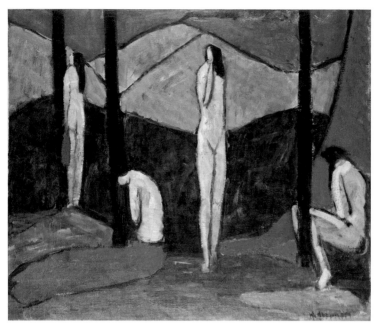

18 *Four Nudes in a Landscape*, 1912, oil on canvas, 82.5 × 100 cm, Fondazione Museo d'arte della Svizzera italiana, Lugano (Canton of Ticino. Donation Baron Eduard von der Heydt)

bolt. In it he not only took up Hölzel's suggestions, he also adopted the Expressionism of Die Brücke, with a free use of color in a flat, clearly structured composition. He celebrated his success in this major shift in a letter to his parents on November 11, 1911: "At the moment I'm painting a seated nude with a bouquet of roses on a table beside her. … I think it's the best thing I've ever painted."[24] With his *Four Nudes in a Landscape* (fig. 18) he took up a subject that Paul Cézanne with his female bathers had established as a paradigmatic theme for modern composition. Painted in late April and early May, 1912, the large-format work proved to be a key achievement, and at Hölzel's urging he promptly submitted it to Munich's *Jury-Free Exhibition* and the *Künstlerbund Exhibition* at Stuttgart's Württembergischer Kunstverein. He was aware that with this new, more expressive painting in flat colors he had made a major change, leaving behind the approaches of traditional academic painting and the expectations of conservative viewers—like his family. Anticipating their response, he wrote:

"It will probably not please you, as it is very modern. But in order to make a name for yourself these days this is the way you have to proceed. All the rest automatically follows."[25]

Hölzel's pupils also profited from summer painting excursions that proved to be vital for their development. In July 1912 they headed to the Eifel region and Montjoie, a town near the Belgian border. Stenner repeatedly captured the town's picturesque half-timbered houses, the unusual circular course of its streets, and its surrounding sweeping landscapes in such paintings as *Montjoie (Monschau I)* (fig. 19), *Rhythmic Landscape, Eifel* (fig. 16), and *Viaduct near Montjoie* (fig. 20). He was also inspired by the altar paintings in the town's churches and by the religious motifs in Hölzel's painting to undertake a series of religious works of his own. His previous impressionistic, sketchy plein-air painting was left behind, and a basically analytical dimension, constructive pictorial composition, and a system of theoretically-founded arrangement of colors came to characterize his art.

STENNER IN PARIS

His intensive studies in Montjoie proved to be of consequence in other respects as well. One of Hölzel's pupils who had come on this excursion was Lily Uhlmann (1887–1974), who had been married since 1908 to the art critic Hans Hildebrandt. On August 23, on the spur of the moment, Stenner and the Hildebrandts decided to head on to Paris, for what would turn out to be a month-long stay, a visit that would be of crucial importance to the young man from Bielefeld. He was overwhelmed by the art metropolis and its manifold impressions. In watercolors and drawings he recorded his impressions of everyday Parisian life beyond (fig. 40) the splendid boulevards in Cubist, angular lines, while in compositions with multiple figures, including nudes, he depicted the city's brothels, music halls, and theater performances, as in the watercolor *Theater Scene* (fig. 21), which can be intepreted as a response to Pablo Picasso's 1907 painting *Les Demoiselles d'Avignon*. Gustav Vriesen rightly considered his Paris drawings the "highlights of his drawing oeuvre."[26] "Stenner's Paris drawings are vibrant with a heightened sense of life. The city's atmosphere, its light, its tempo, the exclusive silence of its broad parks, the crowded life of its streets, the richly nuanced designs in Paris paving—all this is fully present in them."[27]

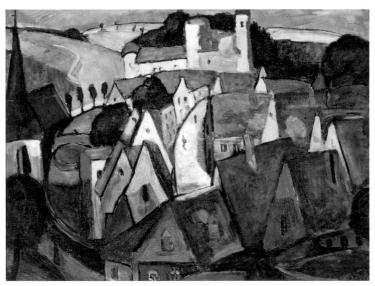

19 *Montjoie (Monschau I)*, 1912, oil on canvas, 80.5 × 110.5 cm, Böllhoff Collection

20 *Viaduct near Montjoie*, 1912, oil on canvas, 53 × 68.5 cm, Sammlung Bunte

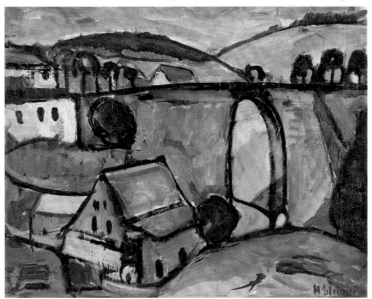

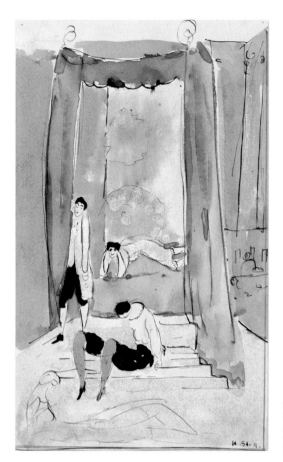

21 *Theater Scene*, 1913,
watercolor, pen, ink,
gold pigment on paper,
28.5 × 17 cm, Sammlung
Bunte

In later drawings Stenner's narratives could also take on a jovial, satirical, even burlesque aspect, as in the watercolor *Suburban Man Pushing a Couple in a Handcart* (fig. 22) from April 1913.

Stenner's growing friendship with Hildebrandt would also have far-reaching consequences. In 1912, shortly after earning his *Habilitation* (postdoctoral lecture qualification), Hildebrandt had been appointed adjunct professor of aesthetics and modern art history at Stuttgart's Technical College. He would continue to teach at the school until June 15, 1937, when the National Socialists withdrew his teaching certification because he was married to a Jewish woman. Hildebrandt was one of the most pro-

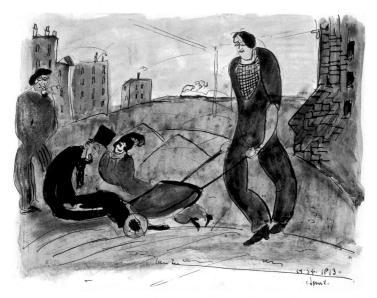

22 *Suburban Man Pushing a Couple in a Handcart*, 1913, watercolor, ink on drawing paper, 24 × 32 cm, Sammlung Bunte

gressive art historians of his time, well acquainted with the artists of the "Hölzel circle" through his wife. In 1914 he made a name for himself with his *Art of the 19th and 20th Centuries*.[28] Lily and Hans Hildebrandt frequently entertained Stenner along with other figures from the Stuttgart cultural scene at their home in Degerloch. Of such gatherings Stenner noted: "Nothing but painters and actors. You can imagine the amount of shop talk."[29] In his book Hildebrandt mentions Hermann Stenner twice, once with regard to the mural paintings for Cologne's *Werkbund Exhibition*,[30] and once again in his evaluation of the analytical pictorial concept in the painting of the "Hölzel circle", which he found to be in contrast to the "radical subjectivism" of Die Brücke's brand of Expressionism.[31] "Hölzel and his so richly gifted school—one thinks of the highly creative young Stuttgart colleague Stenner, lost to the war—only appear to number among the Expressionists. … For they proceed from a desire for order and a command of their medium, not simply from a faith in their brilliant instincts."[32]

Just as Hermann Stenner had previously studied the artistic positions of Late Impressionism with alarming productivity and unerring certainty (fig. 8) and left them behind him, in short order he now experimented with the expressionistic possibilities of a freer coloring (fig. 18), gradually simplifying his colors and employing them in planes so as to achieve a more monumental effect. This is obvious, for example, in his painting *Self-Portrait in Costume (the Roman)* (fig. 23). Stenner had doubtless studied works by the artists of Die Brücke closely, whose compositions in these years epitomized a new search for naturalness, with a reduction of painting materials, motifs, and formal elements, radiant colors, a non-perspective flatness in the concept of space, an anti-academic distortion of figures, and a programmatic turn toward preindustrial, non-European cultures. In his sketchbook from 1912/13 Stenner noted: "And yet it is only this pursuit of the great something in art that gives me no rest and keeps my nerves inflamed!"[33] To be sure, exotic or exoticizing subjects are not found in Stenner's work—if one disregards the motif of masks in the painting *Lady with Masks*, from 1913 (fig. 24)—but a thoroughgoing engagement with the coloristic possibilities of Expressionist painting that ultimately helps him maintain a consistent distance from Hölzel's art. This is especially pronounced in the painting *Green Woman with Yellow Hat I*, from 1913 (fig. 25), structured in vivid combinations of complementary colors. And it is unsurprising that works like this led to the invitation to show his work in the important *Expressionist Exhibition* in Dresden in January 1914.

His mysterious *Crusader with Christ*, from 1913 (fig. 26), is one of the earliest examples of this intensified expressionistic style. Disregarding traditional iconographic narratives, Stenner here pictures two male figures, one swathed in a bright orange-red hooded cloak that is contrasted with his blue nimbus, the other wearing a blue turban and with a magically glowing cross on his yellow chest. In front of the rhythmic pointed arches of the background architecture the two figures are transformed into a dazzling phantasmagoria of complementary color harmonies made up of orange, yellow, green, violet, and red. There is nothing comparable to this bold, expressionistic religious vision in the work of Adolf Hölzel. At this time Stenner also develops an expressively heightened balance of visible reality with the new freedom of opposing color accents and sweeping

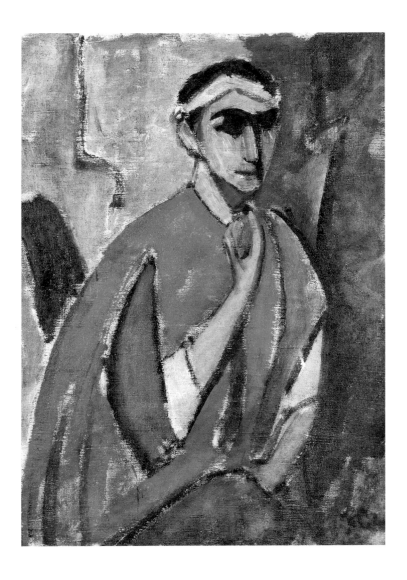

23 *Self-Portrait in Costume (the Roman)*, 1913, oil on canvas, 76.5 × 58.5 cm, Sammlung Bunte

curves in his *Floral Still Life on Black Ground II* (fig. 27). In a different
form, in the fall of 1913, he tests the possibilities of an Expressionist pic-
torial structure in his *Portrait of Itten* (fig. 28), apparently painted shortly
after Itten's arrival in Stuttgart, as well as in the painting *Masks* (fig. 29),
with its figures reduced to ciphers and expressive planes of color. The in-
scription on the back of the latter work, "Itten and Hermann Stenner,"
identifies it as an encrypted double portrait, recalling Hans von Marée's
Self-Portrait with Lenbach from 1863,[34] which he had copied during his stay
in Schleissheim a few weeks before.[35] In early 1914 Itten countered by
picturing Stenner in the painting *Reader*.[36]

It is astounding how self-confidently Stenner integrated into his own
expressive imagery other artistic impressions, ones from the pictures of
Paul Cézanne or of Cubism, for example, made on him when he visited the
Sonderbund Exhibition in Cologne in the summer of 1912. In paintings like
The Red Field (fig. 4), *Cubist Street Scene* (fig. 5), or *Cubist Figure with
Houses* (fig. 6) he integrated such memories into his heightened color and
spatial effects, though without losing sight of his own signature. Above all,
Stenner never took an interest in the reduced Cubist palette of ocher-
beige, gray, and bottle-green tones, to say nothing of the principles of a
prismatic-analytic fragmentation of forms.

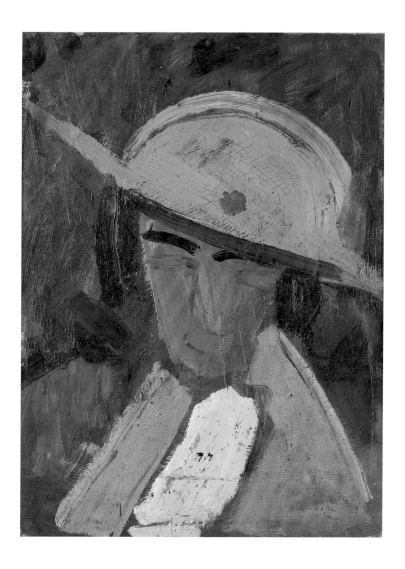

25 *Green Woman with Yellow Hat I*, 1913, oil on cardboard,
42.5 × 38 cm, Sammlung Bunte

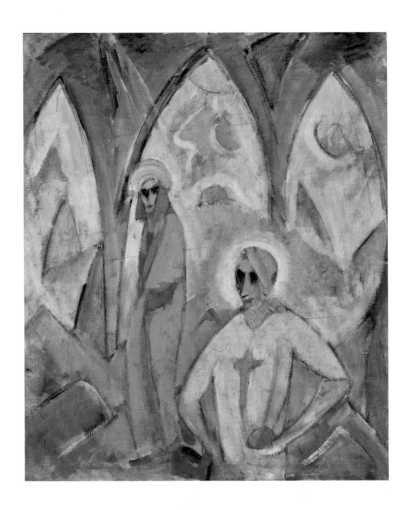

26 *Crusader and Christ*, 1913, oil on canvas, 100 × 84 cm,
Kunsthalle Bielefeld

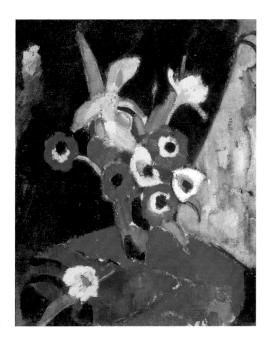

27 *Floral Still Life on Black Ground II*, 1913, oil on canvas, 58.5 × 49 cm, Sammlung Bunte

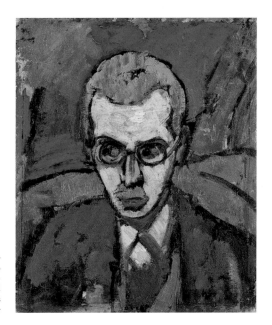

28 *Portrait of Itten*, 1913, oil on canvas, 60 × 50 cm, inv. no. 1303 I.M, LWL-Museum für Kunst und Kultur (Westfälisches Landesmuseum), Münster

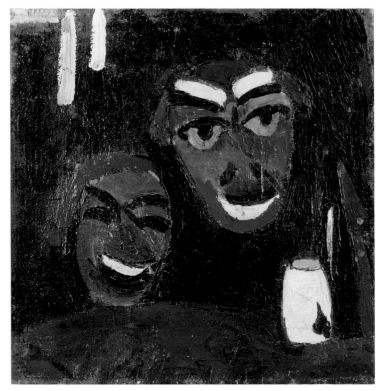

29 *Masks*, 1913, oil on cardboard, 43.8 × 44.2 cm, inv. no. 1306 I.M,
LWL-Museum für Kunst und Kultur (Westfälisches Landesmuseum), Münster

Instead, in paintings like *Head of Christ* or *Woman with Fan* (figs. 30, 31) he experimented with a style of painting, inspired by Expressionism, that deliberately exploits the effects of a seemingly crude, free, alla-prima technique that lets the painting ground show through in spots. Structuring with color, he thereby intensified the immediacy and primitive quality of painterly expression, using methods similar to those of the Brücke painters.

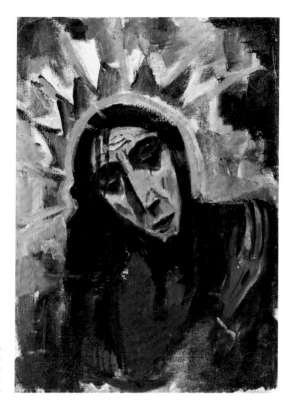

30 *Head of Christ*, 1913,
oil on canvas,
66 × 47 cm (verso:
Portrait of a Lady),
Sammlung Bunte

THE MURAL PAINTINGS FOR COLOGNE'S
WERKBUND EXHIBITION

The most notable artistic commission Hermann Stenner worked on during
his student years in the Hölzel class in Stuttgart is now documented only
in preliminary designs (fig. 32) and photographs. After protracted com-
petition within the class, Adolf Hölzel passed the commission along to his
three master-class pupils Hermann Stenner, Oskar Schlemmer, and Willi
Baumeister. Each of them was to design and execute four panels for the
entrance of the main hall, designed by Theodor Fischer (1862–1938), at the
first *Werkbund Exhibition* in Cologne. The twelve monumental mural
paintings were to picture scenes from the legends of early Cologne saints,

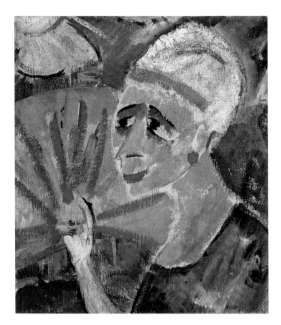

especially the legend of Saint Ursula. Between December 1913 and April 1914 the artists executed their paintings in oil on large-format Ebonit panels (2.50 × 3.75 m), which were displayed to the public in Stuttgart in March and then mounted on the walls of the main hall in Cologne in time for the exhibition's opening. Stenner was well aware that the participation in this first exhibition of the work of the Deutscher Werkbund, a gathering of the "structures and consumer goods" of internationally recognized architects and designers, would greatly enhance the reputations of the participating artists. The organization of the show was overseen by the young head of the Cologne building department, Konrad Adenauer—who would later go down in history as the first chancellor of the Federal Republic of Germany. For Stenner the commission meant at least temporary financial independence, as he emphasized in a telegram to his parents. On February 9, 1914, he euphorically announced: "The location is very favorable, so that with luck our pictures will become one of the chief attractions of the whole exhibition."[37] He canceled his accustomed Christmas

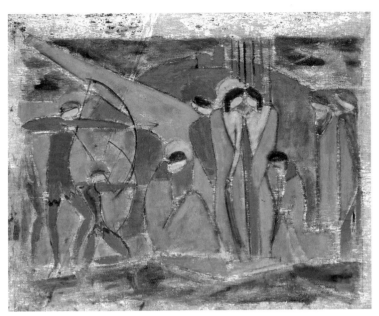

32 *The Execution of Saint Ursula*, 1914, oil on canvas,
103 × 135 cm, Staatsgalerie Stuttgart

visit to his family in Bielefeld in order to be able to keep working in Stuttgart over the holidays on the designs for his mural paintings. The actual combination of avant-garde painting and traditional Christian iconography from the ancient Cologne legends of Saint Ursula doubtless originated with Adolf Hölzel, who had passed along the commission to his pupils, to be sure, but continued to oversee its execution. With one of his aphorisms he had previously admonished his pupils: "One cannot paint with religion!"[38] Accordingly, in Stenner's designs for the commission, as in *The Execution of Saint Ursula* (fig. 32), the iconography and figural motifs are subordinated to the overall rhythm of his geometrically structured compositions and radiant, expressive colors. On February 9, 1914, he self-confidently and programmatically wrote: "We are striving for an expression of our time, and want to open men's eyes to the expressive possibilities of color."[39]

The planning and execution of the large-format mural paintings gave Stenner an opportunity to work out a new monumentalism in his imagery,

combining a geometrically curving figural rhythm with expressive colors. At the same time, the blend of a religious subject and a considerable abstraction in the structure of the figural composition brought him slightly closer to the art of Adolf Hölzel.

His experiences from this time also influenced his subsequent works: *Saint Sebastian* (WV no. 169) and especially the large-format *Resurrection* (fig. 33), which both Schlemmer and Baumeister considered their friend's best work, are striking examples of this. In each of these paintings he develops, from the abstracting treatment of space, figures, and objects, a special internal structure of curves expressively pulsating in reduced color harmonies.

It must have been particularly deflating to Stenner that reactions to the mural paintings were far from euphoric. Whereas the *Vossische Zeitung*'s art critic, Max Osborn, praised the young painters' "bold experimentation" and "forward-looking impetus," the painting was criticized in the *Westfälische Zeitung* as being so "hypermodern that even an artistically broad-minded person could no longer go along with it."[40] In his *Art of the 19th and 20th Centuries* even the altogether well-meaning Hildebrandt wrote of the "not yet fully perfected but promisingly daring mural paintings."[41] Owing to the August declaration of war the *Werkbund Exhibition* was forced to close early, and during the course of the conflict the main building together with its mural paintings was destroyed.

Outwardly unruffled, but inwardly deeply hurt, in early June 1914 Stenner retreated to the seclusion of Meersburg on Lake Constance. There he produced his last paintings, which are dominated by a gloomy, melancholy blue tone at times having the chill of moonlight. One of them, the *Portrait of a Lady with Lily* (fig. 34), painted on rough burlap, portrays his fiancée, Clara Bischoff. Other paintings include the *Two Female Nudes in a Blue Landscape*, the *Blue Nude* (fig. 35) and *The White Boy* (fig. 36). A restrained color harmony no longer enlivened by contrasting colors pervades these pictures and seems to set everything in motion down to the forms themselves. Now, in these last pictures, even the depictions of his beloved fiancée Clara Bischoff (1893–1969), a spirited dancer at Stuttgart's Royal Hoftheater to whom Stenner had been devoted since 1912, seem like dreamlike evocations of happier times, despite the fact that they had been defined by reciprocal outbursts of jealousy. Stenner's letters document the profound psychological tensions that he had expressed in his art over a

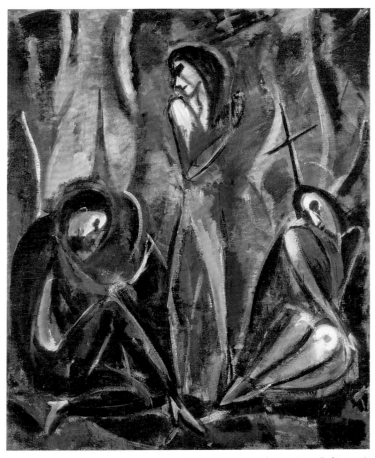

33 *Resurrection*, 1914 (verso: *Women Bathing*, 1912),
oil on canvas, 167 × 143 cm, Sammlung Bunte

long period of time: "If you knew what struggles I have had to fight with
the 'truth in art' alone with myself, how deeply in doubt I am sometimes,
how I search until something is suddenly successful and I feel myself
summoned to certainly make an important contribution in the future,
then you would perhaps think differently of me. I can only prevail when I
create something truly great and entirely new."[42]

Finally, Stenner also painted a view of Meersburg almost mystically trans-
figured, as in the *Fantastic Landscape with Waterfall (Meersburg)* (fig. 37),

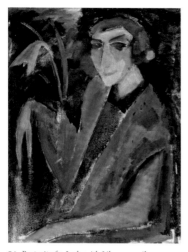 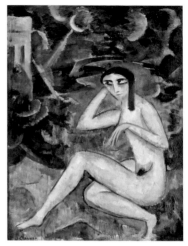

34 *Portrait of a Lady with Lily*, 1914, oil on
rough burlap, 74.5 × 60 cm, Sammlung Bunte

35 *Blue Nude*, 1914, oil on canvas, 135 × 103 cm
(verso: *Execution of Saint Ursula*), Staatsgalerie
Stuttgart, inv. no. L 591

now no longer reduced to a single color but rising up, out of the darkness
like an unreal, expressionistic dream setting. In other pictures, like the
painting *Meersburg* (fig. 38), the colors of that dream setting become
muted and mystically menacing. At the close of his oeuvre, simultaneously
an epitaph and a writing on the wall, is his painting *Funeral Eulogy
(Consecration)* (fig. 39), which after his death—thanks to Johannes Itten—
would become his last artistic salute in the *Exhibition of the New Munich
Secession*. After many years it was only rediscovered in 2005.

"WE'RE AT WAR!"

On July 27, 1914, Stenner and his artist colleagues—as Itten relates—were
alarmed by the imminent preparations for war: "We're at war. Didn't you
know that? … I immediately packed up my things, said goodbye to Hölzel
and to Ida Kerkovius, saw Schlemmer and Stenner, both of whom, dis-
traught, were thinking of enlisting."[43] That same day Stenner wrote his
parents: "Here everything is on edge, people are definitely expecting a war.
Yesterday evening there were huge Social Democratic demonstrations

against the war. It was the most impressive and exciting thing imaginable. The streets were teeming with people. The Social Democrats began marching through the city but were repeatedly dispersed by soldiers and mounted police. Soon the patriots got together and started singing "The Watch on the Rhine," and it wasn't long before the workers' "Marseillaise" was drowned out, despite their whistling and yelling. Powerfully moving, the German national anthem rose into the night out of a thousand throats."[44] In patriotic enthusiasm and with fervid impatience Hermann Stenner and Oskar Schlemmer enlisted on August 7, 1914.[45] In a mix of naive faith in authority, trust in God, and patriotic exuberance, like tens of thousands of their contemporaries, the two set out as enlisted men at the very start of the war to their doom. The Kaiser's inflammatory, nationalistic appeal in the Berlin Reichstag on August 4, 1914, "I know no parties any longer, I know only Germans!", as well as the emotional speech given by the Württemberg king Wilhelm II, had not failed to have their effect on Stenner.

36 *The White Boy*, 1914, oil on canvas, 93.5 × 115.5 cm, inv. no. 1302 I.M, LWL-Museum für Kunst und Kultur (Westfälisches Landesmuseum), Münster

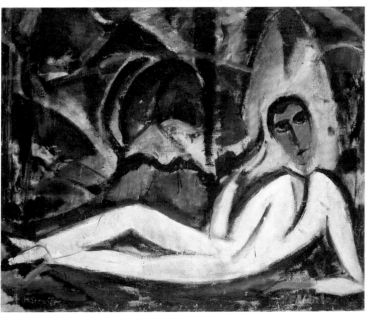

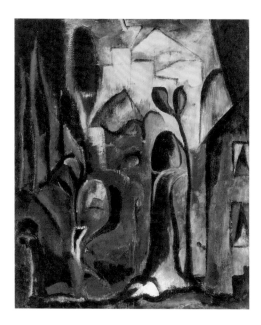

37 *Fantastic Landscape with Waterfall (Meersburg)*, 1914, oil on canvas, 101 × 84 cm, private collection

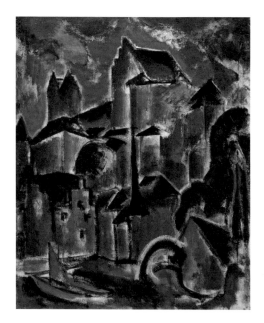

38 *Meersburg*, 1914, oil on canvas, 120.5 × 105 cm, Kunsthalle Bielefeld

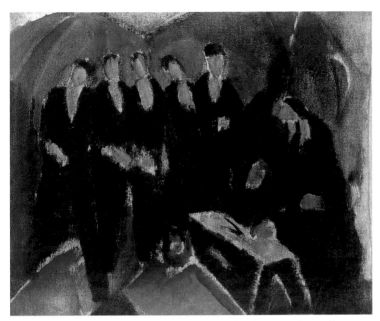

39 *Funeral Eulogy (Consecration)*, 1914, oil on canvas,
43.7 × 53 cm, Sammlung Bunte

That he would meet his death in the same year, in the night of December
4/5 on the Eastern Front, was beyond his—otherwise immensely fertile—
imagination. By mid-August he had already reported to army barracks,
and a few months later, presumably on the morning of December 5, 1914,
he fell in Poland near the town of Iłów in present-day Powiat Sochaczewski
in the Voivodeship of Mazovia. A review of the infantryman Stenner's
postings makes it depressingly clear that from the end of September, as a
volunteer with virtually no military training in Infantry Regiment No. 119,
"Queen Olga"—sent in rapid succession to various battle zones in the Ar-
gonne, then in mid-October in Lille, in November in Flanders, and finally
in late November in Poland—he could have hardly found any assignment
but death.[46]

EPILOGUE

It was the later Bauhaus master Johannes Itten who in March 1915 sent Stenner's painting *Funeral Eulogy (Consecration)* (fig. 39) to the *New Munich Secession*, filling out the form on the delivery tag in his own hand. Under the direction of Stenner's friend, the art historian Hans Hildebrandt, Itten, and Hölzel played a major role in the sorting and safeguarding of Stenner's artistic legacy and establishment of a preliminary list of works. In August 1916—shortly before his own departure from Stuttgart for Vienna—Itten wrote to Stenner's father no fewer than four times to make certain that Stenner's paintings would be represented in the exhibition *Hölzel and His Circle*, which was to open at the Freiburger Kunstverein on September 2, a show that was again presented in 1917 at the Galerie Schames in Frankfurt. Four of his paintings were illustrated in the exhibition catalogue on a par with those of Hölzel, Baumeister, Schlemmer, and Itten. It was these efforts by Stenner's friends and colleagues that would enable the rediscovery of his art half a century later.

CHRISTOPH WAGNER *holds the chair in Art History at the University of Regensburg and is the Institute's director. He has become internationally recognized for his research on the art of Modernism.*

1 *The Fallen. An Exhibition of Nine Artists Who Lost their Lives in World War One*, ed. by Tim Cross, exh. cat. The Museum of Modern Art, Oxford, Oxford 1988, p. 64; Jutta Hülsewig-Johnen and Christiane Reipschläger, *Hermann Stenner. Werkverzeichnis der Gemälde*, Bielefeld 2003.
2 *Cubism and Abstract Art*, ed. by Alfred H. Barr Jr., exh. cat. Museum of Modern Art New York, New York 1936, p. 64.
3 Ibid., p. 153.
4 Herwarth Walden, *Expressionismus. Die Kunstwende*, Berlin: Verlag der Sturm 1918; idem, *Einblick in Kunst. Expressionisms, Futurismus, Kubismus*, 3rd edition, Berlin: Verlag der Sturm 1924; Max Deri, *Die neue Malerei, Impressionismus, Pointillismus, Futuristen*, Munich: R. Piper 1913; Hermann Bahr, *Der Expressionismus*, Munich: Delphin-Verlag 1916 (published in English translation: *Expressionism*, London: F. Henderson 1925); Paul Fechter, *Der Expressionismus*, Munich: R. Piper 1919; Georg Marzynski, *Die Methode des Expressionismus. Studien zu seiner Psychologie*, Leipzig: Klinkhardt & Biermann 1920; Eckart von Sydow, *Die deutsche expressionistische Kultur und Malerei*, Berlin: Furche Verlag 1920.
5 Hans Hildebrandt, *Die Kunst des 19. und 20. Jahrhunderts. Handbuch der Kunstwissenschaft*, Potsdam-Wildpark: Athenaion (1914) 1924, pp. 327, 367.

6 Barr 1936 (as in note 2), p. 153.
7 Götz Keitel, "Mein Grossonkel Hermann Stenner," in: Hülsewig-Johnen and Reipschläger 2003 (as in note 1), pp. 251–258.
8 Hülsewig-Johnen and Reipschläger 2003 (as in note 1), p. 190, with reference to Gustav Vriesen, "Der Maler Hermann Stenner," in: *Westfalen* 35, no. 3 (1957), pp. 146–169.
9 Gustav Vriesen, in: *Hermann Stenner*, exh. cat. Städtisches Kunsthaus Bielefeld, Bielefeld: Städtisches Kunsthaus 1956, p. 2.
10 Quoted in *Aus Willi Baumeisters Tagebüchern. Erinnerungen an Otto Mayer-Amden, Adolf Hölzel, Paul Klee, Karl Konrad Düssel und Oskar Schlemmer. Mit ergänzenden Schriften und Briefen von Willi Baumeister* (Beiträge zur Geschichte der Staatlichen Akademie der Bildenden Künste Stuttgart no. 8), ed. by Wolfgang Kermer, Ostfildern-Ruit: Cantz 1996, pp. 52–53.
11 Barr 1936 (as in note 2), p. 11.
12 See *Sterne fallen. Von Boccioni bis Schiele. Der Erste Weltkrieg als Ende europäischer Künstlerwege*, ed. by Peter Thurmann, Anke Dornbach, and Anette Hüsch, Petersberg: Michael Imhof 2014.
13 Hans Hildebrandt, *Krieg und Kunst*, Munich: R. Piper 1916, p. 255.
14 Letter from March 13, 1912, in: *Der Maler Hermann Stenner im Spiegel seiner Korrespondenz. Briefe 1909–1914*, ed. by Karin von Maur, issued by the Freundeskreis Hermann Stenner e.V., Munich: Prestel 2006, p. 201.
15 Ibid., p. 266.
16 Ibid., p. 263.
17 Stenner's letters in: Hülsewig-Johnen and Reipschläger 2003 (as in note 1), p. 34.
18 Karin von Maur 2006 (as in note 14), pp. 130–132.
19 *Conversations avec Cézanne*, ed. and commented by Michael Doran, Paris: Collection Macula 1978, p. 36.
20 Letter from November 20, 1911, in: Karin von Maur 2006 (as in note 14), p. 208.
21 Sketchbook, entry from February 14, 1912, Sammlung Bunte, Bielefeld.
22 Sketchbook no. 492–566, 1911, Sammlung Bunte, Bielefeld.
23 Karin von Maur 2006 (as in note 14), p. 393.
24 Ibid., p. 181.
25 Letter from May 9, 1912, in: Karin von Maur 2006 (as in note 14), p. 208.
26 Vriesen 1957 (as in note 8), p. 157.
27 Ibid.
28 Hildebrandt 1924 (as in note 5), pp. 327, 367.
29 Letter from November 12, 1912, in: Karin von Maur 2006 (as in note 14), pp. 233.
30 Hildebrandt 1924 (as in note 5), p. 327.
31 Ibid.
32 Ibid., p. 367.
33 Quoted in Hülsewig-Johnen and Reipschläger 2003 (as in note 1), p. 257.
34 Oil on canvas, 54.5 × 62 cm, Bayerische Staatsgemäldesammlungen, Neue Pinakothek, Munich.
35 Jutta Hülsewig-Johnen and Nicole Peterlein (eds.), *Hermann Stenner. Aquarelle und Zeichnungen*, issued by the Freudeskreis Hermann Stenner e.V., Munich: Prestel 2010, p. 341, Z 1505.
36 Christoph Wagner, *Johannes Itten. Catalogue Raisonné, vol. 1. Paintings, Watercolors, Drawings. 1907–1938*, Munich: Hirmer Verlag 2018, p. 140, 1914-009-G; Christoph Wagner, *Johannes Itten* (The Great Masters of Art Series), Munich: Hirmer Verlag 2019, pp. 13–15.
37 Letter from February 9, 1914, in: Karin von Maur 2006 (as in note 14), p. 365.
38 Adolf Hölzel, *Gedanken und Lehren*, ed. by Marie Lemmé, Stuttgart: Deutsche Verlags-Anstalt 1933.
39 Letter from February 9, 1914, in: Karin von Maur 2006 (as in note 14), p. 365.
40 Max Osborn, in: *Vossische Zeitung* May 21, 1914, quoted in: Karin von Maur 2006 (as in note 14), p. 342.
41 Hildebrandt 1924 (as in note 5), p. 327.
42 Letter to his parents from July 4, 1913, in: Karin von Maur 2006 (as in note 14), pp. 309–310, here p. 309.
43 Johannes Itten, "Aus meinem Leben," in: Willy Rotzler, *Johannes Itten – Werke und Schriften*, Zürich: Orell Füssli 1978, pp. 15–29, here p. 25.
44 Letter to his parents from July 27, 1914, in: Karin von Maur 2006 (as in note 14), p. 415.
45 Letter to his parents from August 7, 1914, in: Karin von Maur 2006 (as in note 14), p. 418.
46 Ibid., pp. 403–412.

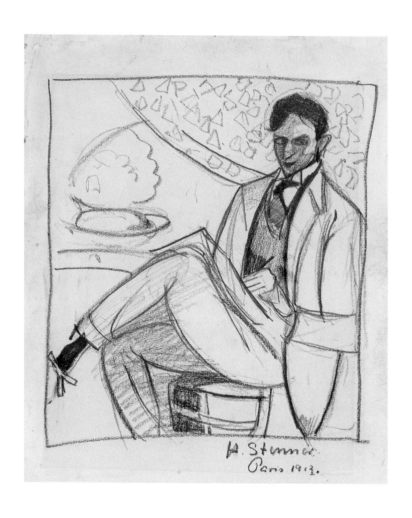

40 *Self-Portrait, Sitting, "Paris 1912"*, 1912, pencil on paper,
23 × 18.8 cm (sheet size: 31 × 22,5 cm), Sammlung Bunte

BIOGRAPHY

Hermann Stenner
1891–1914

1891–1908 Hermann Stenner is born in Bielefeld on March 12, 1891, the first of eight children of the master painter Hugo Stenner and his wife Elise, née Hövener. His father, who had himself attended an applied arts school, enthusiastically supports the artistic ambitions of his son and his other children from the start. The art-minded couple enjoys painting, watercoloring, and drawing, and is associated with the "Wandervögel". Even though they have little money, they never question the need to encourage their gifted first-born. Beginning in early childhood, Hermann learns the artisanal basics of painting in his father's painting shop. In 1908 he finishes high school and for a time attends the progressive craftsman's and applied arts school in his hometown, so as to prepare for study at an art academy.

1909 Because he is especially gifted, as was apparent early on, Stenner is able to take the entrance exam for Munich's Academy of Art, where he hopes to study painting, at the early age of eighteen. Eugen von Stieler, the Academy's acting director, advises him to first enroll in the private painting and drawing school in Munich run by Heinrich Knirr. In addition, Stenner attends the animal and outdoor painter Hans von Hayek's painting school in the Dachau artists' colony.

1910 At the recommendation of both Knirr and von Hayek, Stenner is permitted to transfer, without taking another entrance exam, to the painting class of the Late Impressionist landscape painter Christian Landenberger at the Royal Academy of Fine Arts in Stuttgart, where he immediately distinguishes himself as an outstanding student. The landscapes, portraits, and self-portraits he has painted during the summer in Bielefeld attract attention and praise at the Academy's regular student exhibitions.

1911 Success comes quickly for Stenner. At the *Easter Student Exhibition* his works are singled out for special commendation. In the summer, in his engagement with nature study and landscape, he takes part in important excursions to Diessen on the Ammersee under Landenberger's direction. Trips to a Secession exhibition in Munich provide him with new impressions.

41 The siblings Hermann, Hugo, Fritz, Ferdinand, Erich and Lissi Stenner, 1900

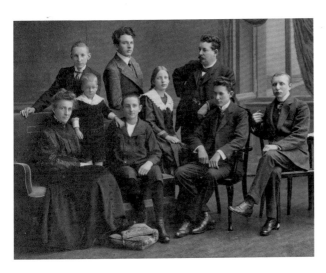

42 The Stenner family at New Year's 1910, back row from left: Ferdinand, Hermann, and father Hugo; front row: mother Elise, the four-year-old Walter, Kurt, Lissi and the twins Hugo and Fritz

His first one-man show at Bielefeld's Galerie Otto Fischer is positively reviewed, especially his painting *Coffee Garden on the Ammersee* (fig. 12). In October he switches to the highly regarded "composition class" of Adolf Hölzel (1853–1934). The 58-year-old Hölzel, one of the precursors of Modernist painting and a professor, artist, and theoretician at the Stuttgart Academy from 1905 to 1919, has gathered together a growing circle of gifted young artists. Hölzel is of decisive importance to Stenner as well as others with his wide-ranging teaching on art theory.

Along with 24 fellow Hölzel pupils Stenner is represented at the *Christmas Exhibition of Composition Students*, where his painting *Cannstatt Bridge* (fig. 13) is singled out for praise in the *Staatsanzeiger für Württemberg*. He also exhibits his *Steamer on the Ammersee* (WV no. 69), *Landscape with Poplars* (WV no. 31), *Garden with Flag* (WV no. 66), *Neckar Bridge* (WV no. 192, lost), *Trees with Two Figures by the Lake* (fig. 11), and *Still Life with Apples* (fig. 14), and even sells a floral still life for 100 marks. But Stenner's financial situation is still difficult. On December 18 he applies for a scholarship from the City of Bielefeld, hoping to be able to do without monthly payments from his family, but without success.

1912 As a Hölzel master-class pupil, in March Stenner is able to move into one of the coveted master-class pupil studios, which in addition to a view of the palace park provides him with the comfort of heated rooms at no cost. He spends July painting intensively with the Hölzel class in Montjoie (known as Monschau after 1918) in the Eifel near the border with Belgium. On the way there he visits the epochal *Sonderbund Exhibition* in Cologne, where he is able to study firsthand leading exponents of French contemporary painting from Paul Cézanne to Paul Gauguin, and above all the expressive painting of Vincent van Gogh. Whereas Cézanne and Gauguin are represented with 25 works each, and Paul Signac with 18, there are more than 100 by Van Gogh, 30 by Edvard Munch, and 16 by Pablo Picasso. Like many of his German artist colleagues, Stenner is profoundly impressed by the visit, though he writes nothing about it in his journal.

On August 23 he travels in the company of the art historian Dr. Hans Hildebrandt (1878–1957) and his wife Lilly (née Uhlmann, 1887–1974) to Paris for four weeks. Stenner is overwhelmed with new impressions in the

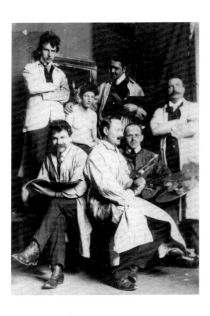

43 Hermann Stenner (standing in the back on the left) with Landenberger pupils and models in a studio, 1910

44 In Schlemmer's studio "Untere Anlage" in front of his wall painting *Miracle of the White Nuns* for the Cologne *Werkbund Exhibition* in the spring of 1914, standing from the left: Hermann Stenner, Karl Bürckle, Oskar Schlemmer; seated: Edmund Kinzinger

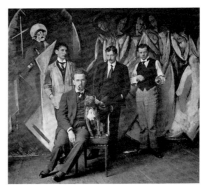

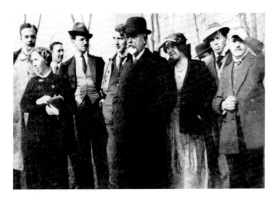

45 Adolf Hölzel and some of his pupils, 1914, from the left: Alfred Wickenburg, Ida Kerkovius, unknown, Edmund Kinzinger, Hermann Stenner, Adolf Hölzel, Lily Hildebrandt, Willi Baumeister, Oskar Schlemmer, Heinrich Eberhard

fast-paced art metropolis with its glorious boulevards. He airily comments on the Frenchwomen's addiction to cosmetics, possibly only to reassure his family back in staid Bielefeld. In drawings he records his impressions of theaters and music halls and everyday Parisian life. Following academic tradition, in the Louvre he studies the Old Masters, among them Giotto, Mantegna, Titian, and the expressive imagery of El Greco.

On his return to his hometown Stenner initially returns to traditional motifs in a style that seems little advanced, but this has been interpreted as an accommodation to his concerned relatives and a way to improve the chances of selling his pictures. In fall he participates with two decidedly Expressionist pictures at the *Jury-Free Exhibition* in Munich and again with two paintings at the *Künstlerbund Exhibition* at Stuttgart's Württembergischer Kunstverein. In December he is invited to send works to the exhibition of Berlin's New Secession in the upcoming January.

In this year Stenner has become romantically involved with the dancer and actress Clara Bischoff (1893–1969), a performer at Stuttgart's Hoftheater. She becomes his muse, model, lover, and fiancée. "Clabi," as she is professionally known, is now his preferred model, appearing in his paintings *Portrait of a Lady with Lily* (fig. 34) or *Blue Nude* (fig. 35). In 1919 "Clabi" will end her ten-year career as a dancer in the Stuttgart opera ballet with the role of Salomé. She will work for a time as a technical draftsman, then in 1926 begin studying weaving at the Bauhaus in Dessau. She will later settle near Ascona as a freelance handweaver. Although in letters to his parents Hermann routinely describes his friends and acquaintances in detail, he does not mention "Clabi" at all.

1913 In this year Stenner engages intensively with artistic positions of the contemporary European avant-garde movements and repeatedly exhibits his work in group shows. In May he shows paintings in Halle, and from May 10 to the end of October his paintings *Carrying the Cross* and *Young Man* are included in Munich's *Jury-Free Exhibition*.

Also in May he is able to contribute six paintings to a show that also features Oskar Schlemmer and Willi Baumeister at the Neuer Kunstsalon am Neckartor in Stuttgart, recently founded by Schlemmer. These are harshly criticized in the Swabian press. All five of the drawings Stenner submits to the *International Black & White Exhibition* in Vienna are

accepted, and shown next to pictures by Max Liebermann, Edvard Munch, Egon Schiele, and Gustav Klimt. In July he shows three paintings and seven drawings at Berlin's *Jury-Free Art Exhibition*; starting August 25 six paintings and a dozen drawings at Munich's Neuer Kunstsalon; and finally starting October 25 paintings, drawings, and graphics at Bielefeld's craftsmen's and applied arts school—his last show in his hometown during his lifetime.

From June to August Stenner takes part in the annual Academy excursion, this time to Schleissheim, with side trips to Munich, Freising, and other nearby towns. His father tries to arrange regional commissions to help his virtually destitute son make a living, one for painting a restaurant interior, another a cemetery chapel, but is unsuccessful. In this situation Adolf Hölzel passes along to his three master-class pupils Baumeister, Schlemmer, and Stenner a prestigious commission: mural paintings for the main hall, built by Theodor Fischer, at Cologne's *Werkbund Exhibition*. Between December 1913 and mid-April 1914 the three artists design and paint a cycle of twelve large-format pictures on subjects from Cologne's history. The paintings are not executed in situ, but rather in Stuttgart on fiber-cement panels—manufactured under the trade name Eternit since 1903 —then transported to Cologne to be mounted on the walls. At year's end Stenner is invited by Dr. Richard Reiche, from Barmen, to participate in the exhibition *The New Painting* in Dresden, later better known under the title *The First German Expressionist Exhibition*. Stenner succinctly comments: "I consider it my first major success" (postcard from December 15, 1913).

1914 At this important Expressionist exhibition at the Galerie Ernst Arnold in Dresden, which includes such prominent painters as Alexej von Jawlensky, Wassily Kandinsky, Ernst Ludwig Kirchner, Paul Klee, August Macke, Franz Marc, Egon Schiele, Lyonel Feininger, Emil Nolde, and Max Pechstein, Stenner shows his paintings *Flower Piece* and the now lost *Coffee Concert*.

At the same time he is engaged in the execution of the mural paintings for Cologne's Werkbund building, which he inspects on February 6/7 together with Hölzel and Schlemmer. In March the paintings are first shown in Stuttgart, then officially unveiled at the *Werkbund Exhibition* on

May 16. Between March and May Stenner is caught up in a frenzy of exhibition activity: at Nürtingen's art exhibition (April), at the Kunstsalon Schaller in Stuttgart (March/April, together with Hölzel, Alfred Heinrich Pellegrini, Schlemmer, Baumeister, and Pechstein), and again in Stuttgart at the *Art Exhibition of the Society of Friends of Art in the Countries on the Rhine*, where Stenner shows two paintings, one of them his *Resurrection* (fig. 33). In mid-April he sets out for Amsterdam with Baumeister and Schlemmer for several days.

He paints his last pictures in Meersburg, on the shore of Lake Constance, where he spends June and July on the Stuttgart Academy's annual excursion.

Back in Stuttgart, on August 7 Stenner, like Oskar Schlemmer, enlists in the army, and is assigned to Infantry Regiment No. 119, "Queen Olga." On October 6, after his first few sorties on the Western Front, he writes: "My entire former life is like a single, beautiful dream compared with the harsh reality I am now living in." In late November his regiment is transferred to the Eastern Front. Near Iłów, 68 kilometers west of Warsaw, his unit engages Russian troops in the night of December 4/5. In the battle several hundred soldiers on both the German and Russian side are killed, among them Hermann Stenner. The entry in the regimental diary for Hermann Stenner reads: "fallen 5/12/14 near Iłów." His parents are notified of his death on January 27, 1915. Stenner is presumably buried in a mass grave on the battlefield. A part of art history lies with him.

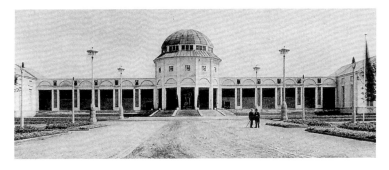

46 View of the main hall of the Cologne Werkbund Exhibition, 1914, for which Stenner produced some of the wall paintings

47 Clara Bischoff, Stenner's fiancée, in the role of Salomé

48 Hermann Stenner as a soldier, front of a postcard to his parents, November 30, 1914

SOURCES

Gustav Vriesen, "Der Maler Hermann Stenner,"
in: *Westfalen* 35, no. 3 (1957).
Hans Georg Gmelin, *Hermann Stenner 1891–1914*,
Munich: Thiemig 1975.
Jutta Hülsewig-Johnen and Christiane
Reipschläger, *Hermann Stenner – Werkverzeichnis
der Gemälde*, issued by the Freundeskreis
Hermann Stenner e.V., Bielefeld: Strothmann
(2003) 2005.
*Der Maler Hermann Stenner im Spiegel seiner
Korrespondenz. Briefe 1909–1914*, ed. by Karin von
Maur and the Freundeskreis Hermann Stenner
e.V., Munich and Berlin: Prestel 2006.
*Sammlung Bunte. Positionen der Klassischen
Moderne*, ed. by Burkhard Leismann, exh. cat.
Kunstmuseum Ahlen, Bramsche: Rasch Verlag
2007.
*Hermann Stenner 1891–1914. Von Bielefeld nach
Meeersburg – Ein Maler an der Schwelle zur
Moderne*, ed. by Kai-Michael Springer, exh. cat.
Schloss Achberg, Ravensburg: Landkreis
Ravensburg 2007.
Jutta Hülsewig-Johnen and Nicole Peterlein,
Hermann Stenner – Aquarelle und Zeichnungen,
issued by the Freundeskreis Hermann Stenner
e.V., Munich: Prestel 2010.
Christiane Heuwinkel and Christoph Wagner,
Hermann Stenner (Junge Kunst no. 32), Munich:
Klinkhardt & Biermann Verlag 2019.

Hirmer Verlag GmbH
Bayerstrasse 57–59
80335 Munich
Germany

Cover illustration: *Sketch for a Self-Portrait*
(detail), 1912, see page 34
Pages 2/3: *Crusader and Christ* (detail), 1913,
see page 46
Pages 4/5: *Four Nudes in a Landscape* (detail),
1912, see page 37
Back cover:
The Red Field, 1913, see pages 18/19

© 2021 Hirmer Verlag GmbH
© for the text: Christoph Wagner

www.hirmerpublishers.com

TRANSLATION
Russell Stockman

EDITING
David Sánchez Cano

DESIGN AND PRODUCTION
Rainald Schwarz, Munich

LITHOGRAPHY
Reproline mediateam GmbH, Munich

PRINTING AND BINDING
Passavia Druckservice GmbH & Co. KG, Passau

Printed in Germany

The Deutsche Nationalbibliothek lists this
publication in the Deutsche Nationalbibliografie;
detailed bibliographical data available on the
Internet at http://dnb.d-nb.de

ISBN 978-3-7774-3823-8